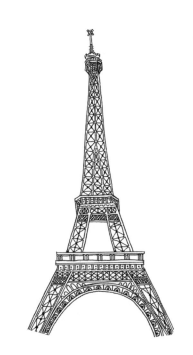

Color

Paris

HARPER
DESIGN
An Imprint of HarperCollins Publishers

Color Paris

HarperCollins books may be purchased for educational,
business, or sales promotional use. For information please email
the Special Markets Department at SPsales@harpercollins.com.

Published in 2016 by
Harper Design
An Imprint of HarperCollins*Publishers*
195 Broadway
New York, NY 10007

Tel: (212) 207-7000 Fax: (855) 746-6023
harperdesign@harpercollins.com
www.hc.com

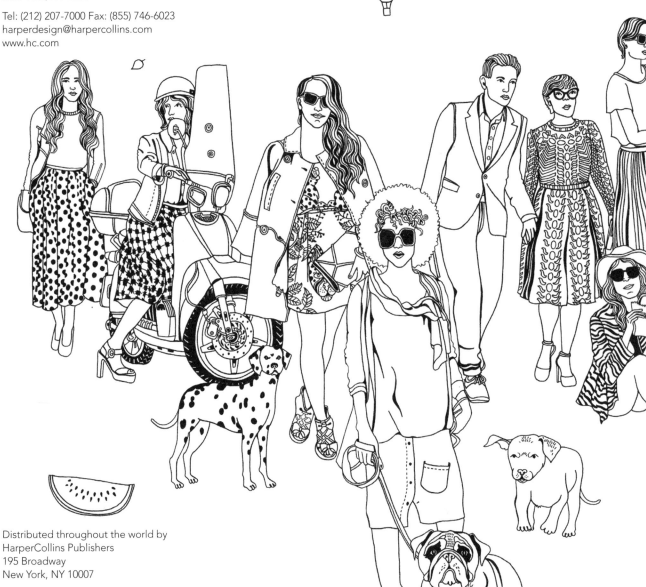

Distributed throughout the world by
HarperCollins Publishers
195 Broadway
New York, NY 10007

ISBN 978-0-06-244513-1

Library of Congress Control Number: 2015949980

Printed in China

First Printing, 2016

This book was conceived, designed, and produced by
Ivy Press
210 High Street, Lewes, East Sussex BN7 2NS, UK

This book
belongs to

...
...
...
...
...

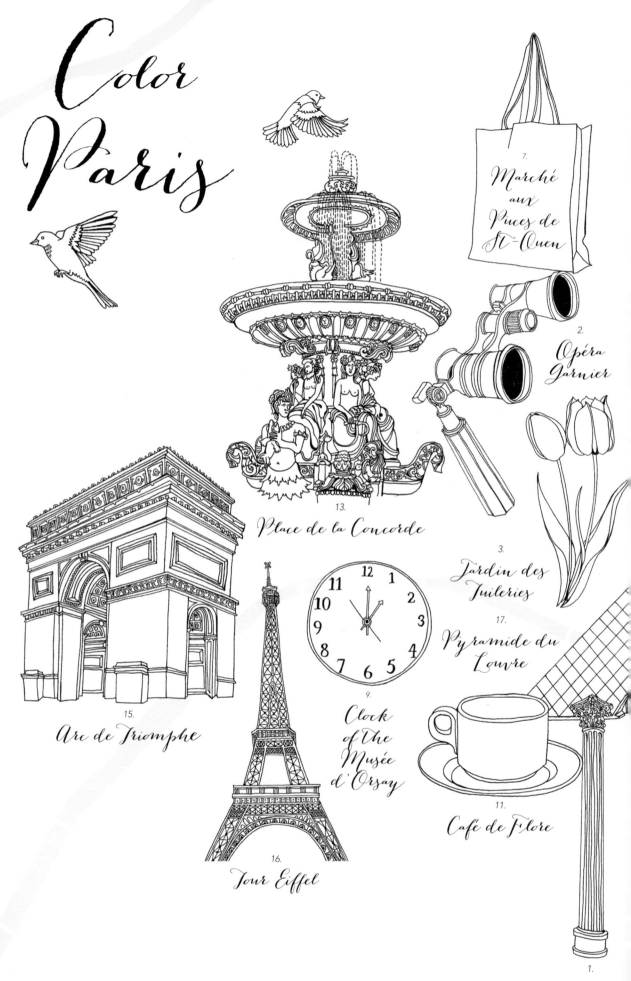

Color
Paris

7.
Marché
aux
Puces de
St-Ouen

2.
Opéra
Garnier

13.
Place de la Concorde

3.
Jardin des
Tuileries

17.
Pyramide du
Louvre

15.
Arc de Triomphe

9.
Clock
of The
Musée
d'Orsay

11.
Café de Flore

16.
Tour Eiffel

1.
Panthéon

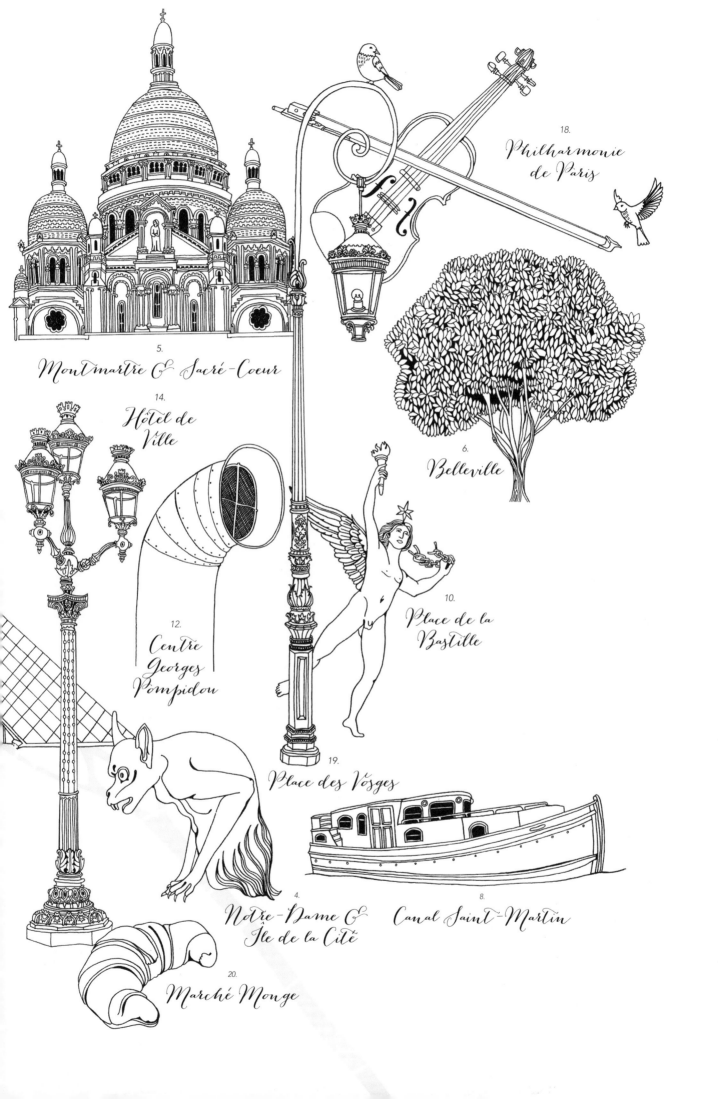

5.
Montmartre & Sacré-Coeur

14.
Hôtel de Ville

12.
Centre Georges Pompidou

18.
Philharmonie de Paris

6.
Belleville

10.
Place de la Bastille

19.
Place des Vosges

4.
Notre-Dame & Île de la Cité

8.
Canal Saint-Martin

20.
Marché Monge

Introduction

Cityscapes always offer terrific scope for the keen observer of detail, and the buildings of Paris have more to offer than most: rolling landscapes of roofs in a hundred subtle shades of gray, green, and blue; vivid gilded statuary and a rich array of public sculpture; and extraordinarily elaborate façades with bright, surprising pops of color—whether window boxes, posters, or twinkling lights—on every corner. And the city is far more than the sum of her architecture: there's the bustling life of the cafés and markets, and, strolling along the avenues, some of the most eye-catching and fashion-conscious citizens in the world.

Color Paris reproduces twenty street scenes from the French capital, painstakingly recorded, from cobblestones to coffee cups. Sometimes you'll be offered the familiar but from an unexpected viewpoint (looking up into the Eiffel Tower, for instance); elsewhere you're given the chance to stand back and admire individual elements you might not have noticed if you were actually there: the glamorous nereids of the Place de la Concorde's fountains, perhaps, or the intricate details of the clock of the Musée d'Orsay. It's an opportunity for a thoroughly enjoyable virtual tour of Paris.

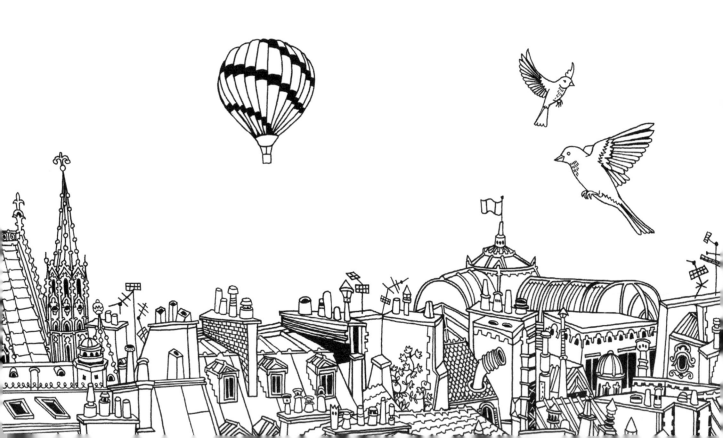

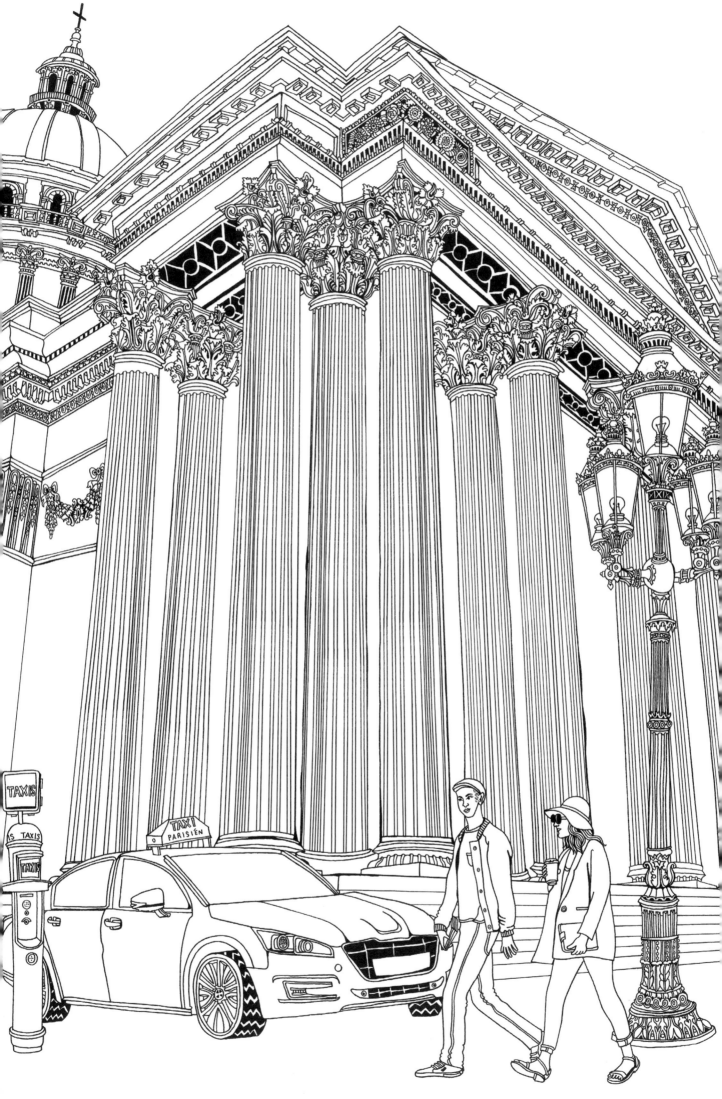

previous page

1.

Panthéon

High in the Quartier Latin, the sheer scale of the Paris Panthéon might momentarily blind you to its elaborate features—a porticoed façade based on its Roman namesake and a dome inspired by the masterworks of the Renaissance. Started in 1758 but taking thirty years to finish, its vast interior is just as awe-inspiring, while down in the crypt a cluster of great people is interred—Voltaire, Jean-Paul Marat, Victor Hugo, Jean-Jacques Rousseau, Émile Zola, and Marie Curie among them.

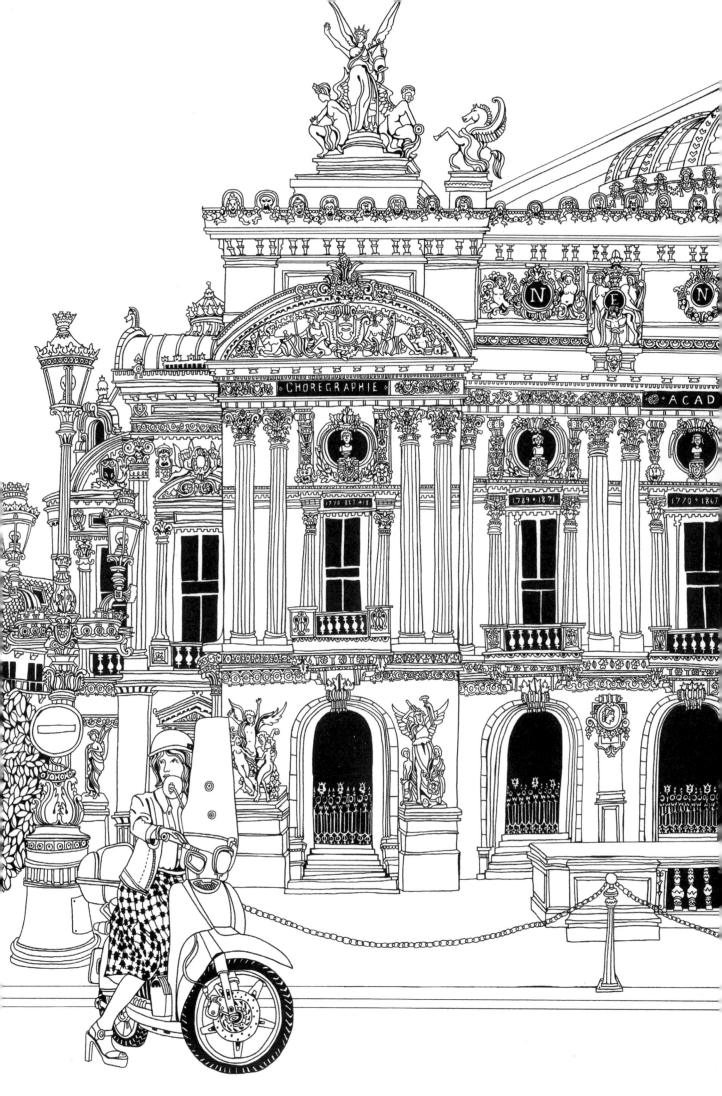

previous page

2.

Opéra Garnier

Named for its architect Charles Garnier, Opéra Garnier opened
in 1875, but its florid style and large size didn't win over everyone:
"It looks like an overloaded sideboard" sneered one journalist.
But the so-called sideboard has easily outlasted its critics and is now
recognized as a masterpiece of Second Empire. Its opulent exterior
is topped by the gilded figures of Harmony and Poetry (Harmony on
the left), and embellished with an absolute forest of detail, including
repeated "Ns"—for Napoléon III, who commissioned it.

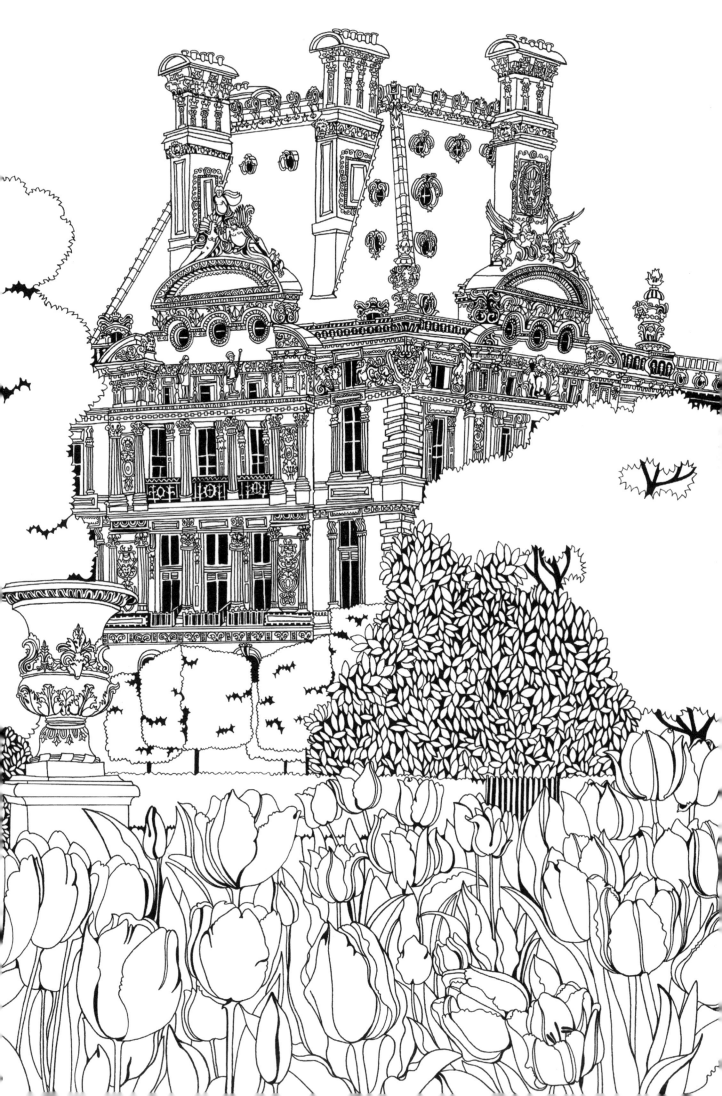

previous page

3.

Jardin des Tuileries

Laid out in the formal style of most great French gardens,
the Jardin des Tuileries, adjacent to the Palais du Louvre,
offers copious statuary, fountains, and broad beds of flowers.
So many great names have strolled along these paths, including
Catherine de Médicis, Marie Antoinette, and the child king
Louis XIII, that today's visitors might wonder at how lightly
the garden wears its history.

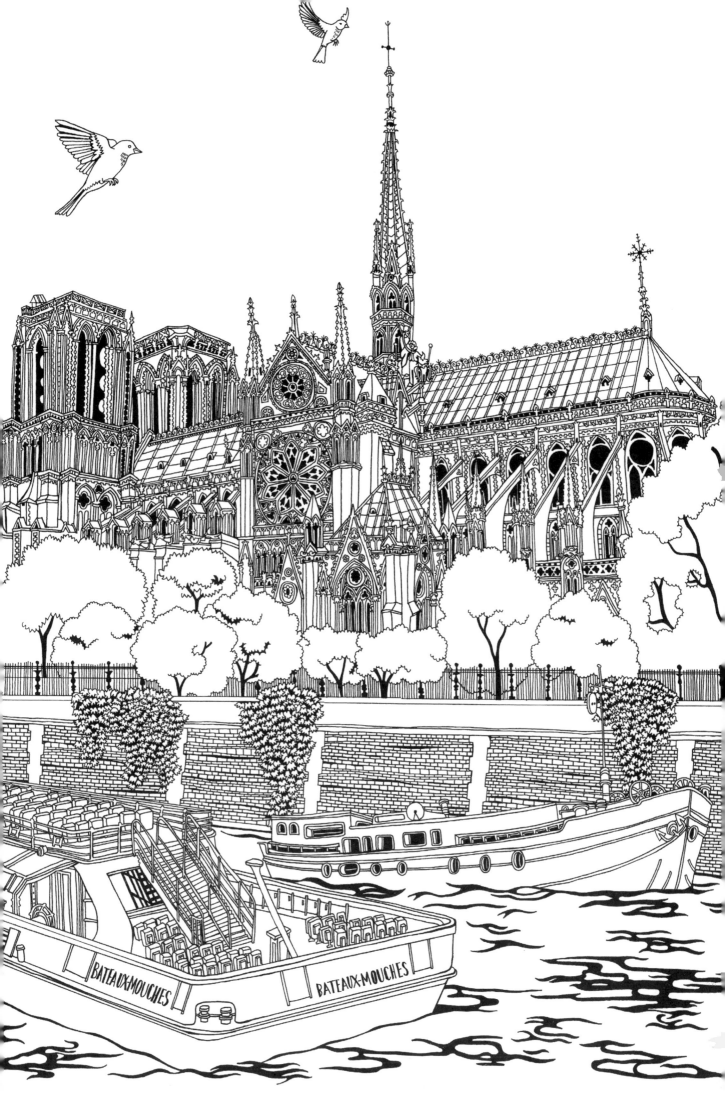

previous page

4.

Notre-Dame & Île de la Cité

Since its completion in the thirteenth century, Cathédrale Notre-Dame has serenely surveyed the city from the Île de la Cité. It has presided over plagues and revolutions, seen packs of wolves roam around its island in the fifteenth century, and set the scene for Victor Hugo's most famous novel—and still remained untouched by it all. Today, Paris has become busier than ever, and bateaux-mouches crowd the river, yet the atmosphere of the gardens around the cathedral remains calm and tranquil.

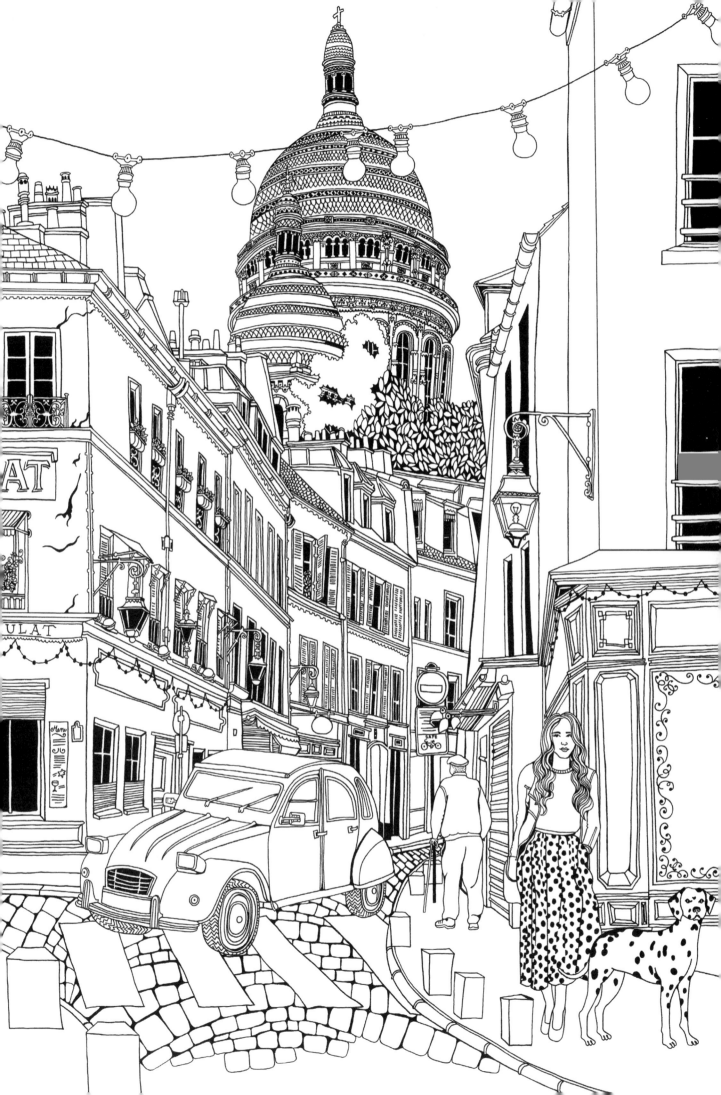

previous page

5.

Montmartre & Sacré-Coeur

High in the 18th arrondissement, crowned by the white basilica of Sacré-Coeur, Montmartre is famous as the historic artists' district of Paris. It's an area that can be crowded with visitors, but take just a couple of turns off one of the main thoroughfares and there are still plenty of corners where the atmosphere of the old quarter lingers on—in backstreet bars and cafés, and cobblestone lanes clustered with plaques commemorating the artists and writers who once lived and worked here.

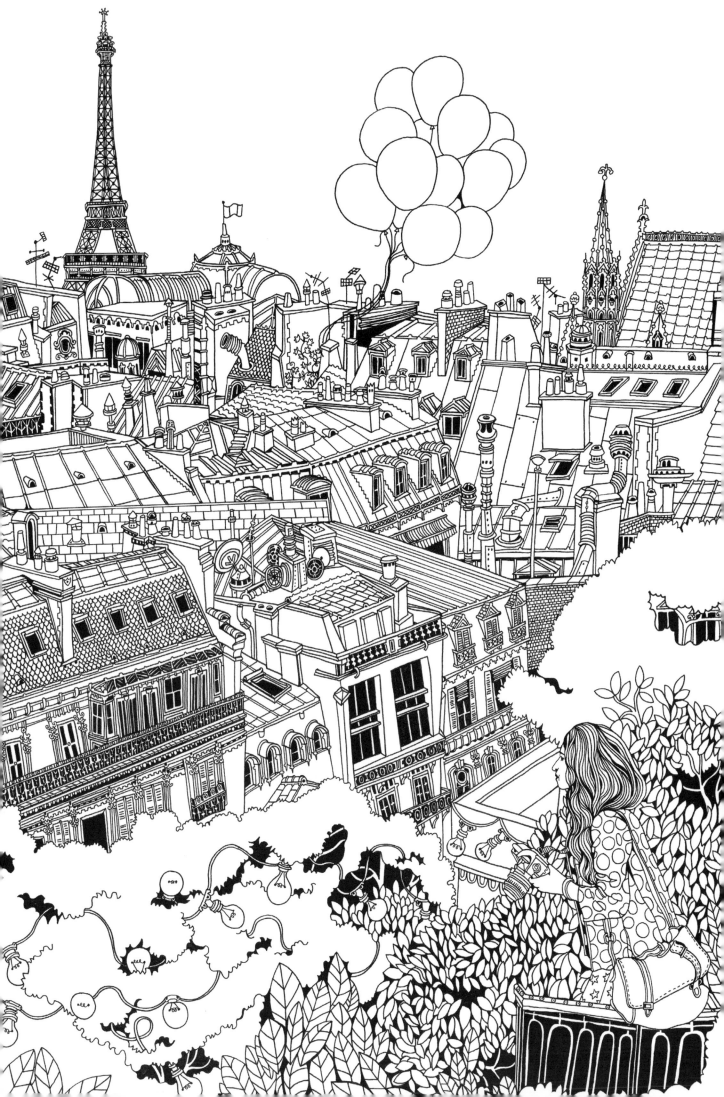

previous page

6.

Belleville

Two hundred years ago Belleville was a hilltop farming village surrounded by vineyards. Long since sucked into the environs of Paris, today it's a diverse suburb with a relaxed vibe. Its cafés, shops, and bistros are beloved by *bobos*—the "bourgeois-bohème" crowd, who know a good thing when they see it. From the right spot on a clear evening the views across the rooftops are the best in Paris.

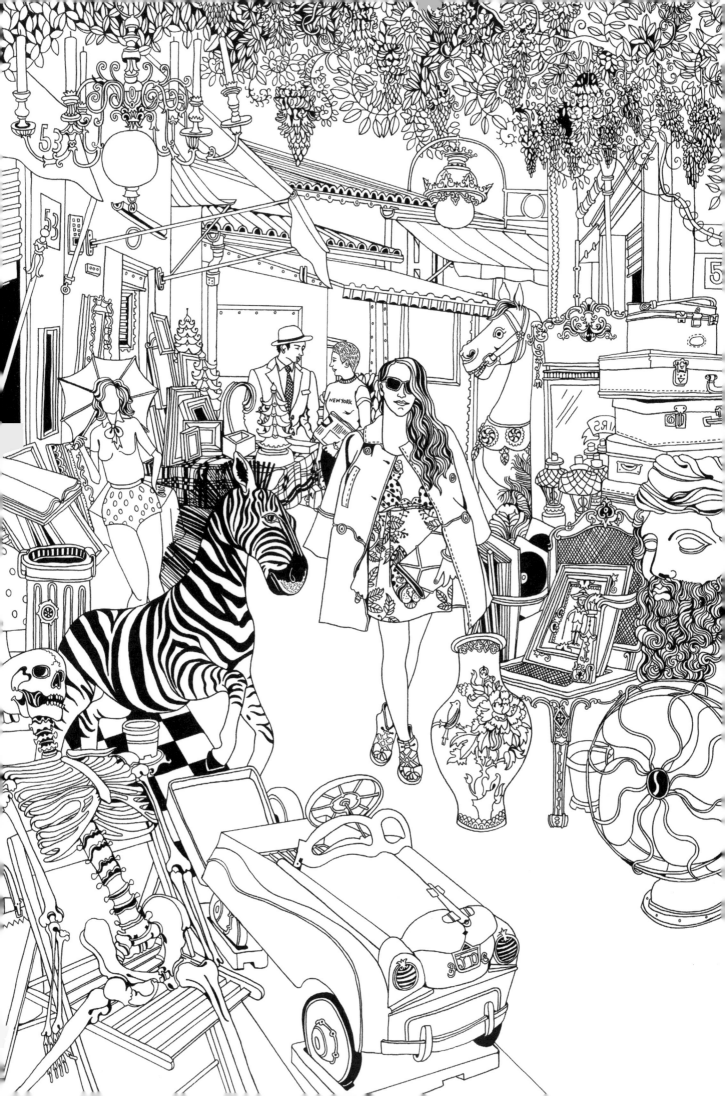

previous page

7.

Marché aux Puces de St-Ouen

Fifteen different markets pulled together on one site, Les Puces, in northern Paris, is the largest flea market in the world and, dating from 1885, one of the oldest, too. Whether you want vintage kitchenware or clothing, antiquarian books, prints, furniture, or signage, there will be a street that specializes in it. Perhaps the best and most random of all the market areas is Marché Lécuyer: if you simply don't know what you want, take a stroll down its alleys, and you won't come away empty-handed. Open from Saturday to Monday (apart from the holiday month of August), the markets repay a relaxed approach: you can also enjoy a meal, listen to live music, or just window-shop and enjoy the sheer variety of goods on offer.

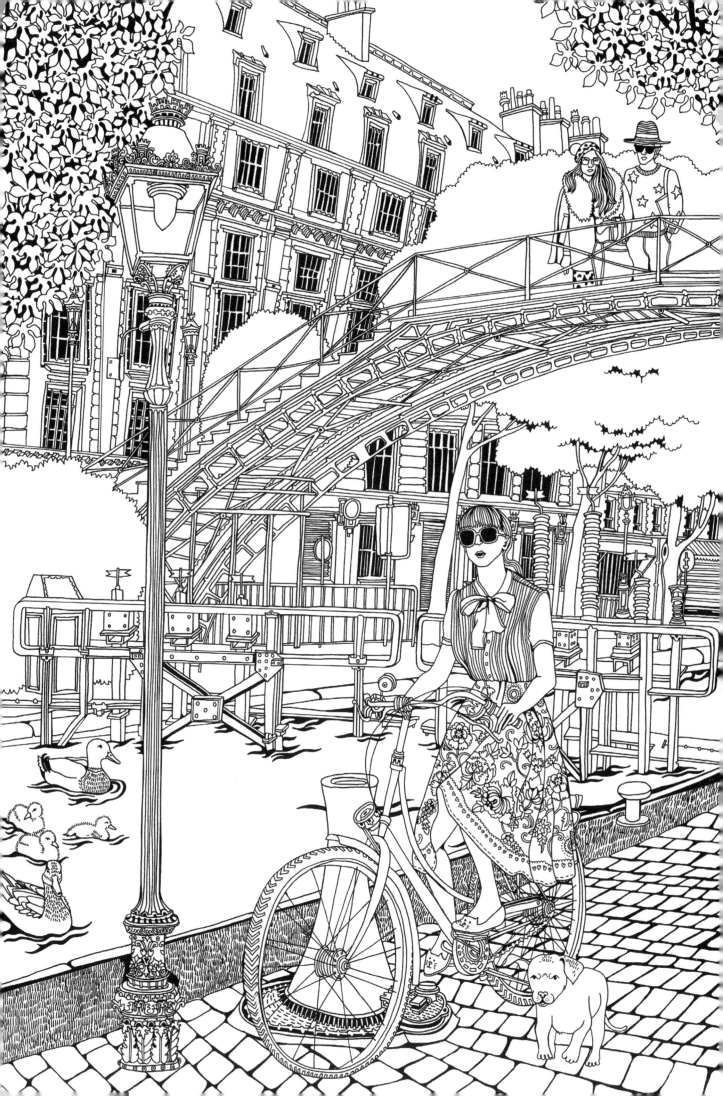

previous page

8.

Canal Saint-Martin

Constructed at the beginning of the nineteenth century to bring fresh water to northeast Paris, today Canal Saint-Martin in the 10th arrondissement is a good choice for an evening or weekend amble. Plenty of tiny cafés and boutiques line streets such as the quai de Valmy, and you can cycle along the cobblestone banks or towpaths past locks and the canal's characteristic iron footbridges, or simply sit on a bench and watch the world go by.

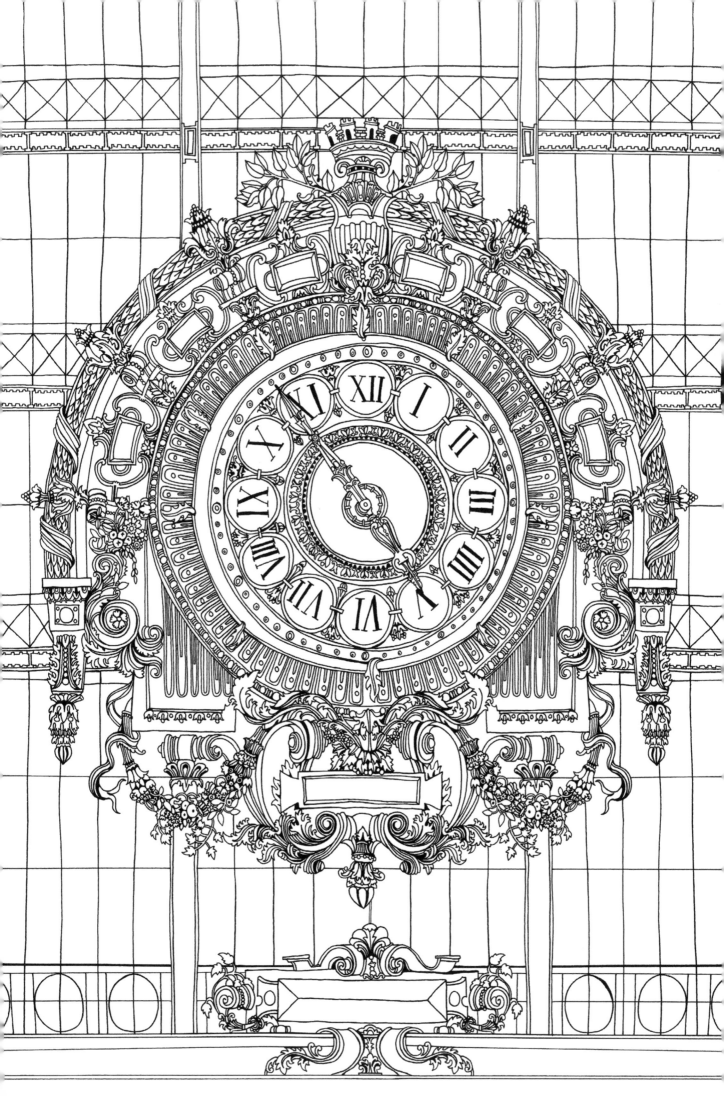

previous page

9.

Clock of The Musée d'Orsay

No visitor to the Musée d'Orsay needs reminding that it was once a station. Three magnificent clocks—two on the north façade (one facing the Tuileries and the other the Seine) and a third inside—offer enough time-checking facility to satisfy the fussiest traveler. The extravagantly gilded clock in the main hall, an extraordinarily elaborate tour de force of the clockmaker's skill, nowadays looks down over some of the most popular exhibits in Paris.

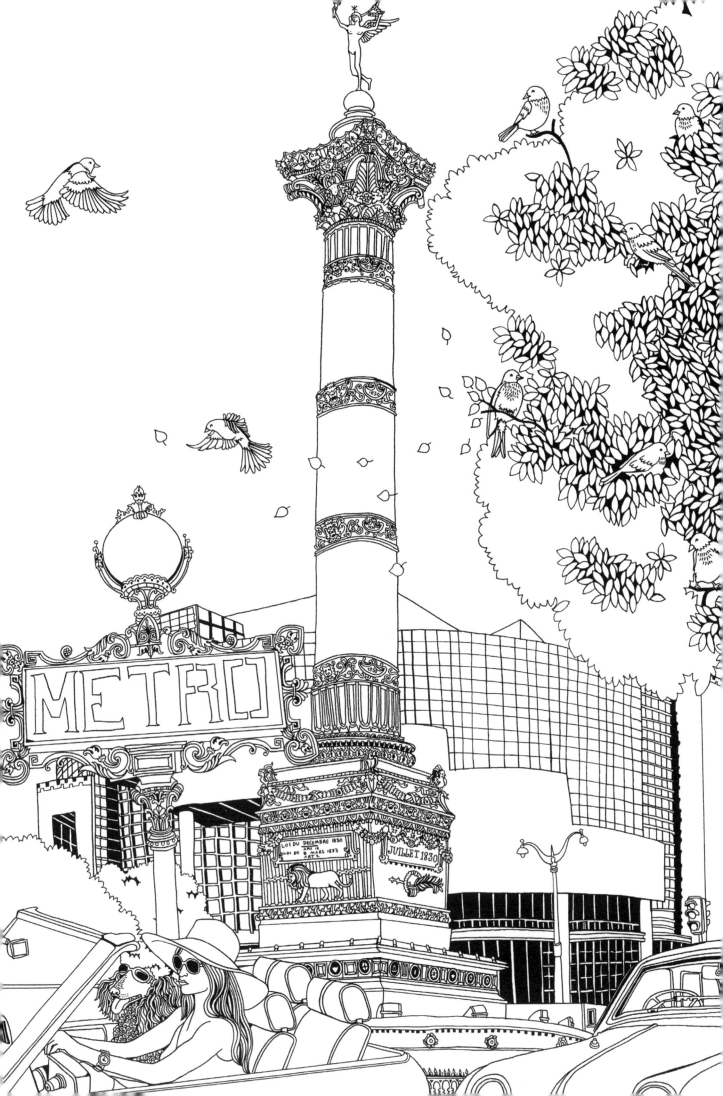

previous page

10.

Place de la Bastille

Renowned as the spot where the French Revolution started,
the infamous prison that gave Place de la Bastille its name is today
marked only by a small row of stones. The eye-catchers in the square
are the green-and-bronze column topped by the gilded figure of
Auguste Dumont's *Génie de la Liberté*, dating from 1836, and Carlos
Ott's huge Opéra Bastille, opened in 1989 as part of the celebrations
marking the revolution's 200-year anniversary.

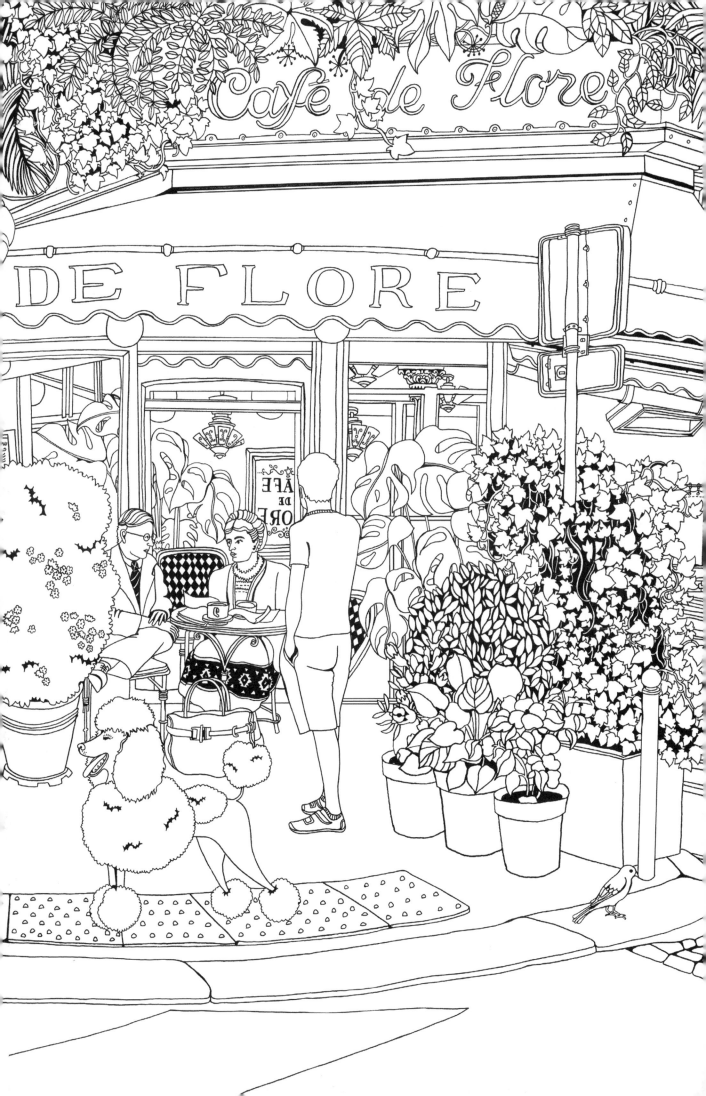

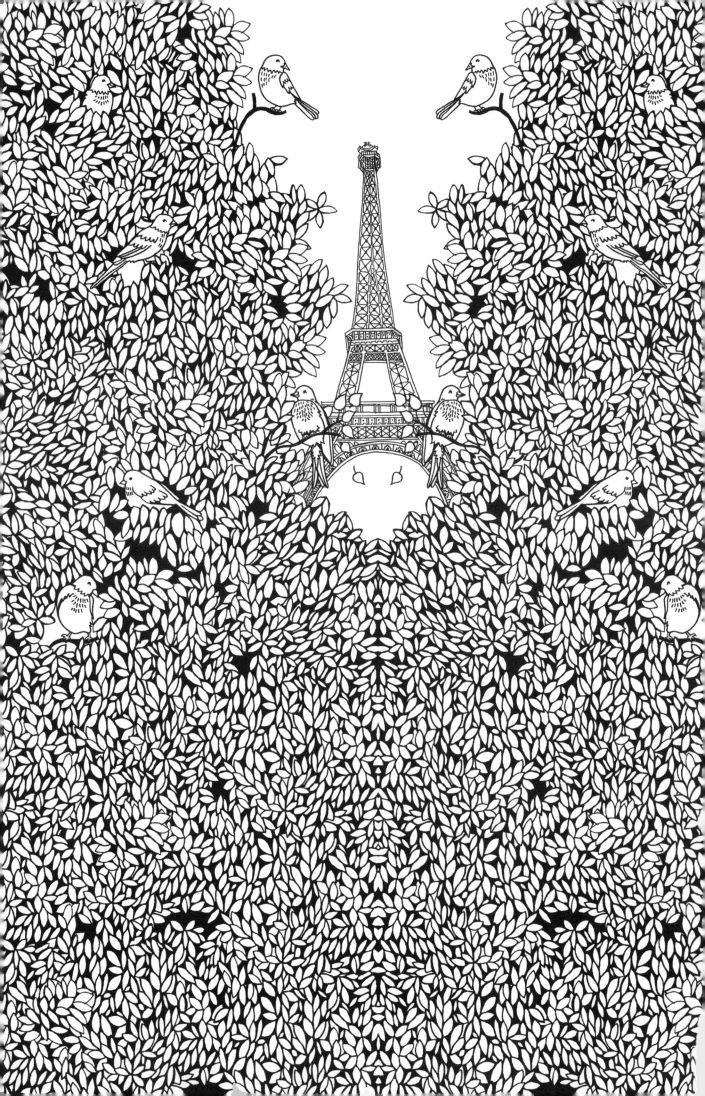

previous page

11.

Café de Flore

"In Flore, people are less ugly than anywhere else" declared Juliette Gréco—praise indeed from the beatnik chanteuse and actress. Perhaps it's that elusive beautifying effect that has made Café de Flore a landmark ever since it opened in the 1880s. Holding court at the junction of boulevard Saint-Germain and rue Saint-Benoît, in the 6th arrondissement, it's still the favored coffee or digestif stop for everyone from intellectuals to tourists.

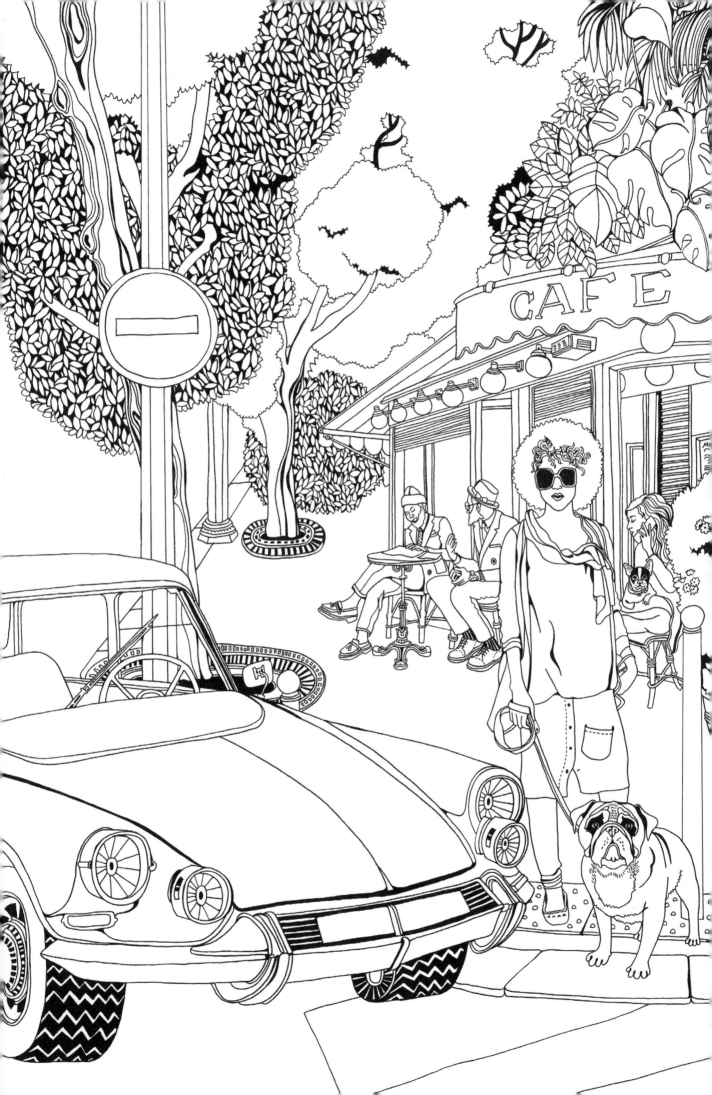

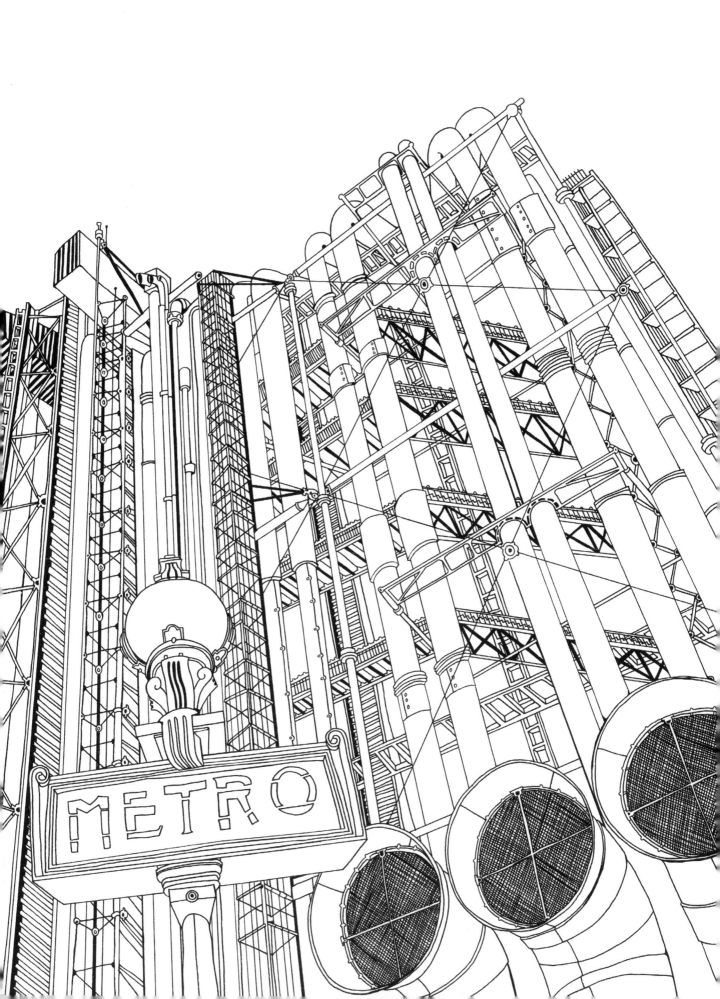

previous page

12.

Centre Georges Pompidou

"A monster . . . just like the one in Loch Ness" complained *Le Figaro*
in 1977 when the Centre Pompidou, designed by an architectural
team headed up by Renzo Piano and Richard Rogers, opened in
Beaubourg. But with familiarity came affection for the cultural center,
which famously wears its workings on the outside, housed in vivid
green, blue, yellow, and red pipes. Today, nearly forty years on,
the building is a veteran reminder of Paris's incomparable eye for
the fresh and the modern in architecture.

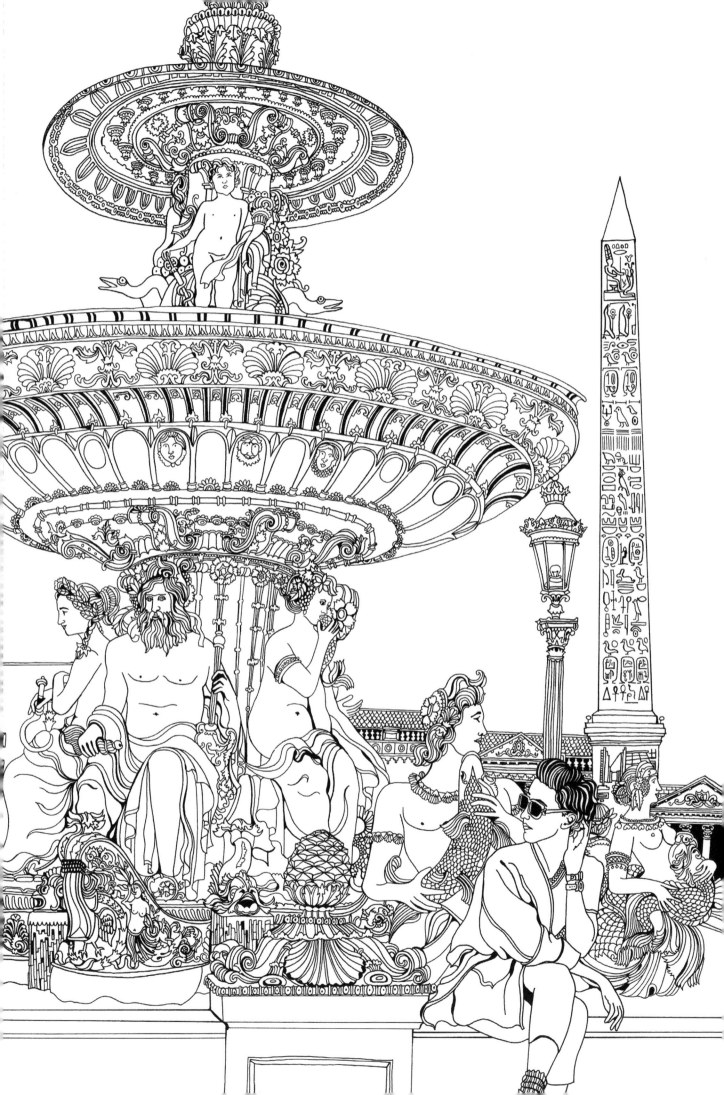

previous page

13.

Place de la Concorde

Bordered on one side by the Champs-Élysées and on the other by
the Jardin des Tuileries, Place de la Concorde offers one of the best
and busiest street panoramas in Paris, framed by some of its most
extravagant statuary. Two flamboyant nineteenth-century fountains
offer focal points, one dedicated to rivers (the Rhône and the Rhine)
and the other to seas and oceans (the Mediterranean and the Atlantic).
Covered in lavishly rendered nereids, fish, dolphins, and tritons,
they are looked over by the gold-topped Luxor obelisk.

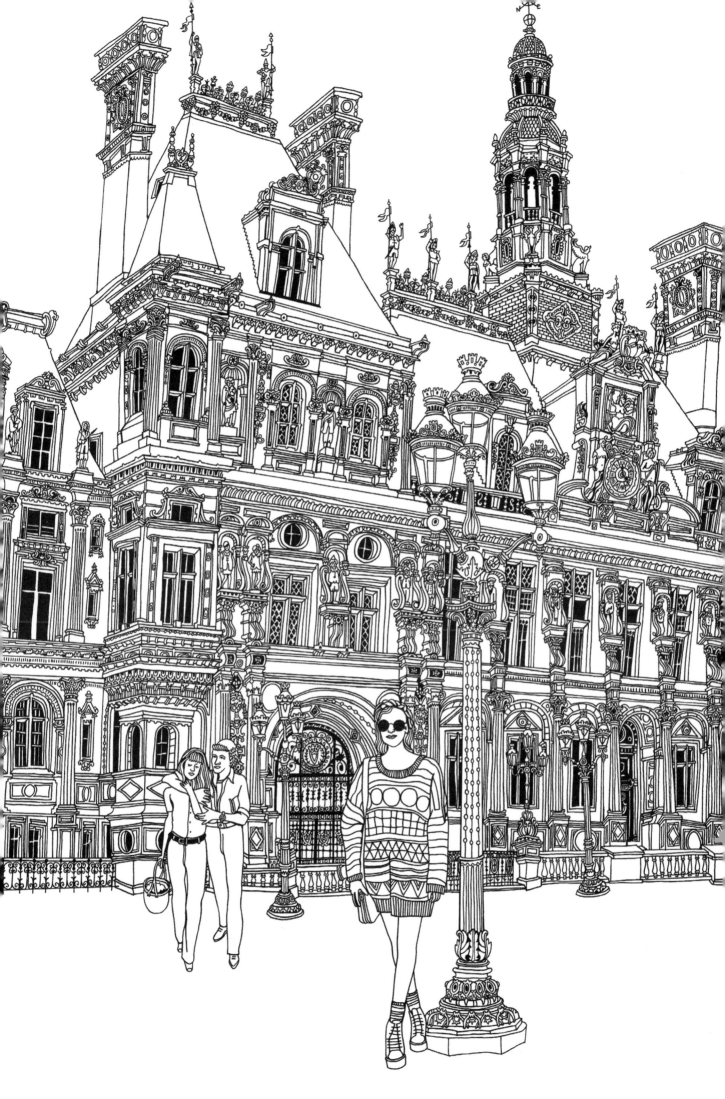

previous page

14.

Hôtel de Ville

The administration hub of Paris, the Hôtel de Ville, or City Hall,
is housed in a gloriously ornate building in the 4th arrondissement.
It's been in its central location since the fourteenth century, although
the high-Renaissance-château style of its current incarnation—niches
with statues and windows with lunettes—dates from only the 1870s.
The vast Place de l'Hôtel de Ville, which it towers over, was—in its
previous incarnation as the Place de Grève—the site of most of
the city's public executions.

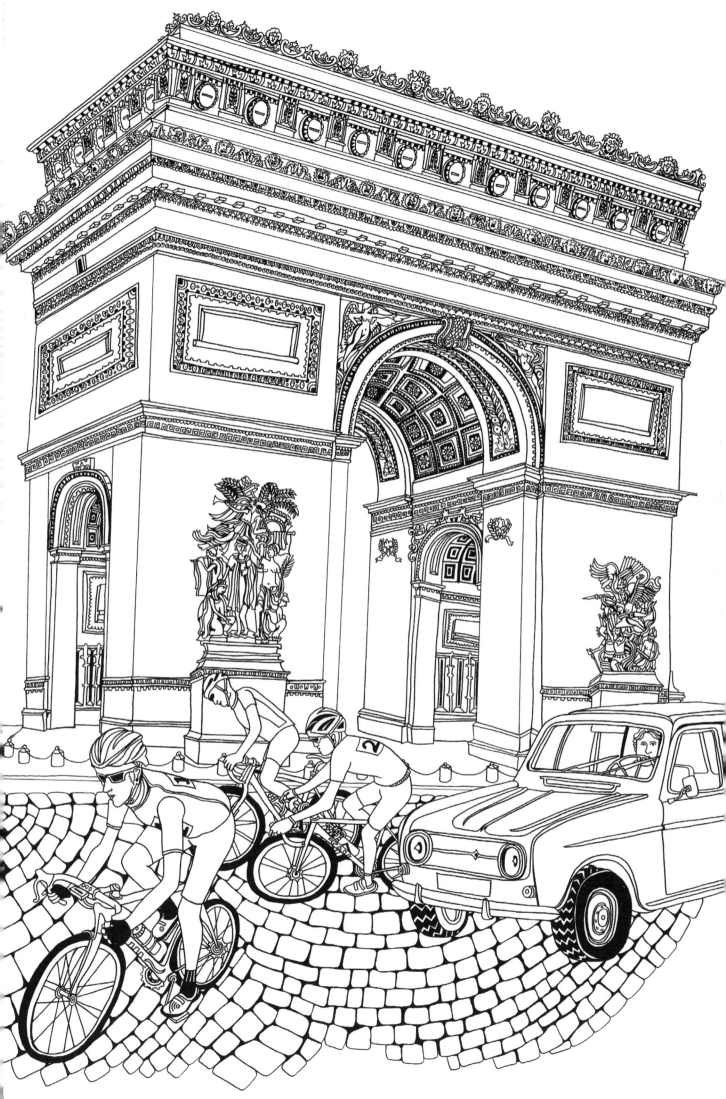

previous page

15.

Arc de Triomphe

The rapid-fire final loop of the Tour de France has only recently been extended around what is arguably the second most recognizable landmark in Paris. Big enough to fly a biplane through (back in 1919 someone actually did) and impressive enough to mark the towering achievements of Napoléon I (whose victory at Austerlitz in 1805 inspired its construction), the Arc de Triomphe also enjoys an iconic view—straight down the Champs-Élysées.

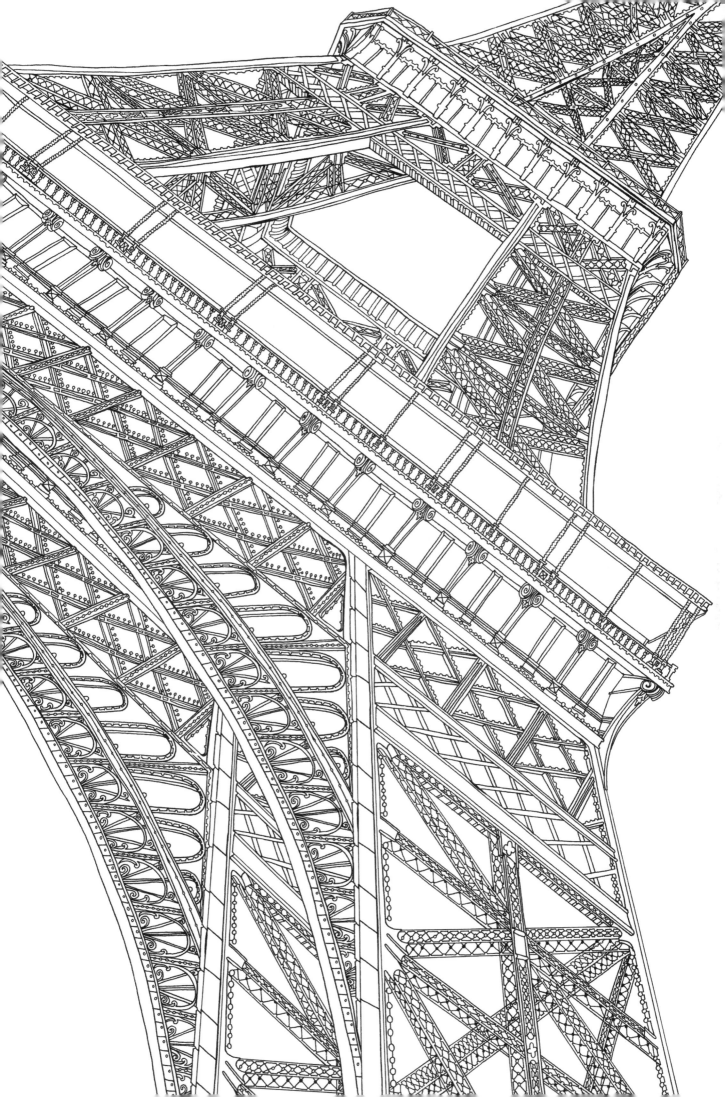

previous page

16.

Tour Eiffel

The quintessential symbol of France for many, this immense lattice of iron girders has loomed over the city since 1889. It has 1,665 steps for the intrepid (most visitors take the elevator), and is illuminated at night by 20,000 sparkling bulbs. Its architect, Gustave Eiffel, loved it so much that he kept an apartment nearby, but not everyone was so enthusiastic. Many complained about the design when it was first introduced—the famous French writer Guy de Maupassant was a regular at the tower's restaurant, claiming it was the only spot in Paris where he didn't have to look at it.

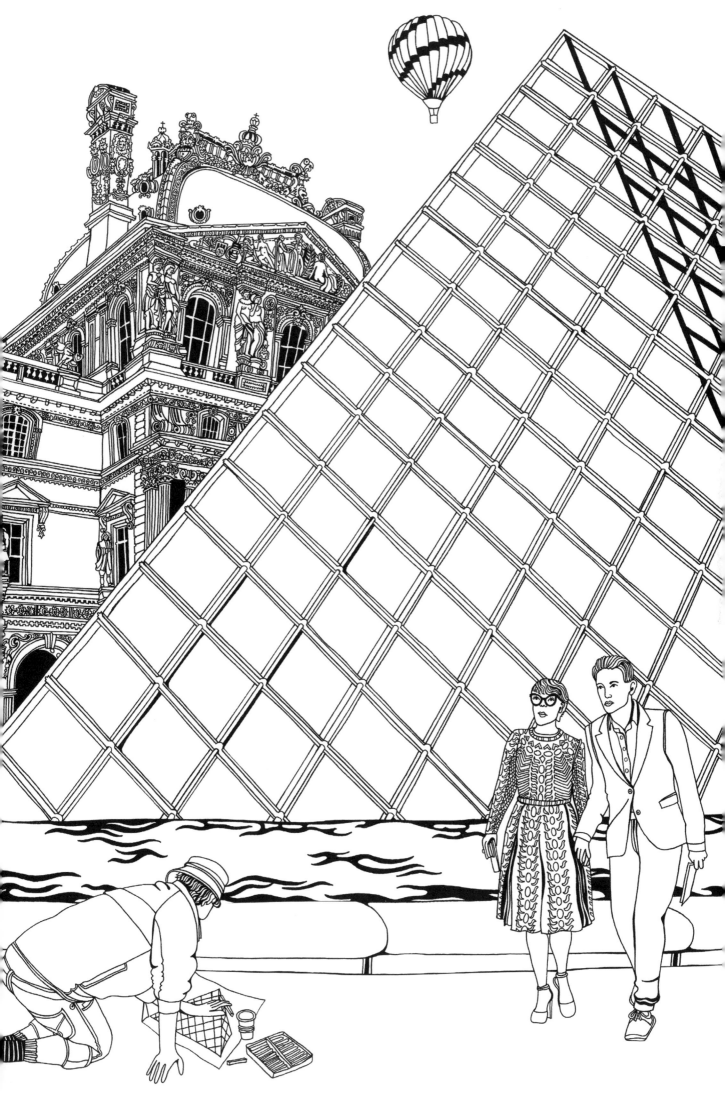

previous page

17.

Pyramide du Louvre

The windows of one of the world's most venerable art museums look out over an innovative solution to an overcrowded entrance hall—I. M. Pei's striking glass Pyramide. This is a truly successful alliance between old and new, built in the Cour Napoléon outside the Louvre as a new subterranean entrance to the gallery. Paris has never feared novelty: whatever the Sun King would have thought about this upstart extension to his Paris residence, most visitors (and Parisians) love it.

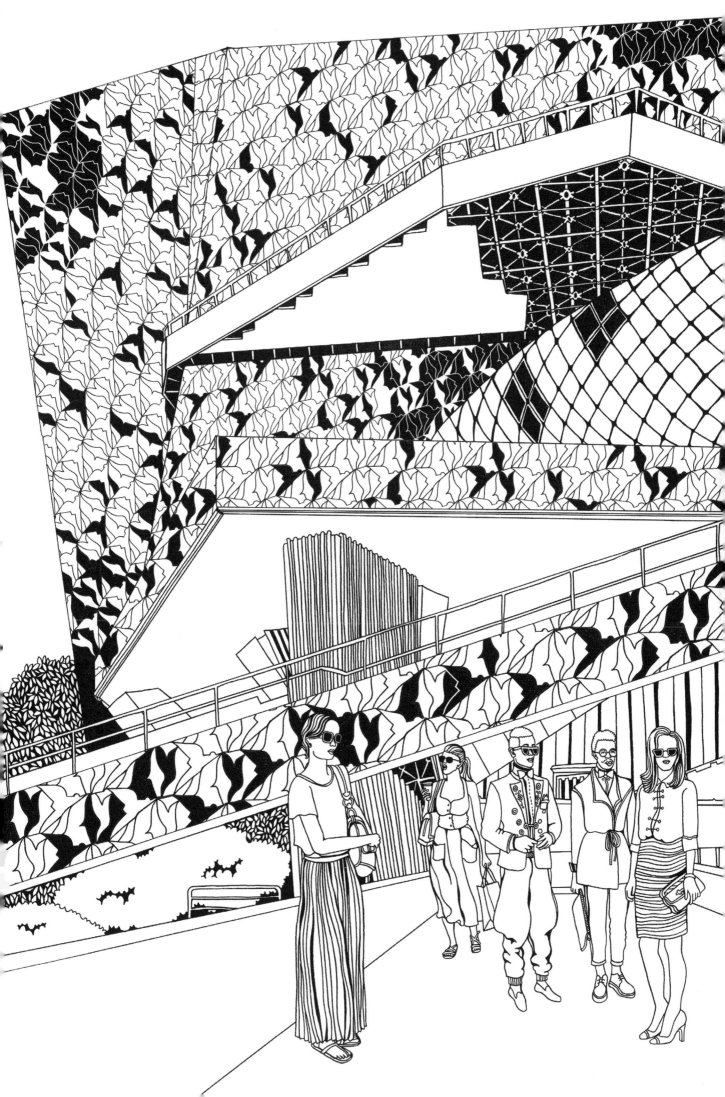

previous page

18.

Philharmonie de Paris

Its detractors compared Paris's grand cultural complex to a spaceship that had crash-landed by the Parc de la Villette. The new Philharmonie auditorium, which includes a 2,400-seat symphony hall designed by Jean Nouvel, opened in January 2015, two years late, three times over budget, and after plenty of controversy. But no one could deny how imposing it is: the bird-shaped aluminum tiles of its cladding can be seen glittering from far away, and it's topped off with a dramatic roof terrace where the public can picnic.

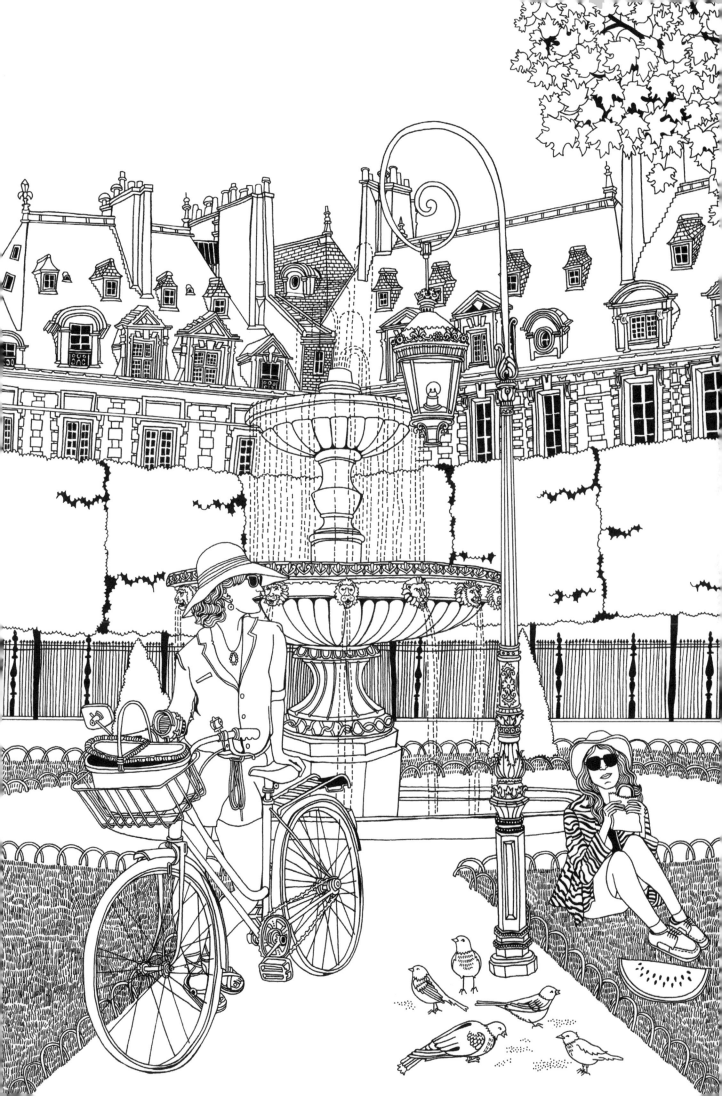

previous page

19.

Place des Vosges

An oasis in the Marais, Place des Vosges is one of the earliest examples of city planning—Henri IV laid it out in the early seventeenth century. Executed with true Parisian panache, it has nine grand houses on each side, arches for carriages and foot traffic, and a pretty central park edged with neatly trimmed trees. In the (distant) past, Madame de Sévigné and Victor Hugo walked here; today, Parisians picnic by the fountain or under the trees.

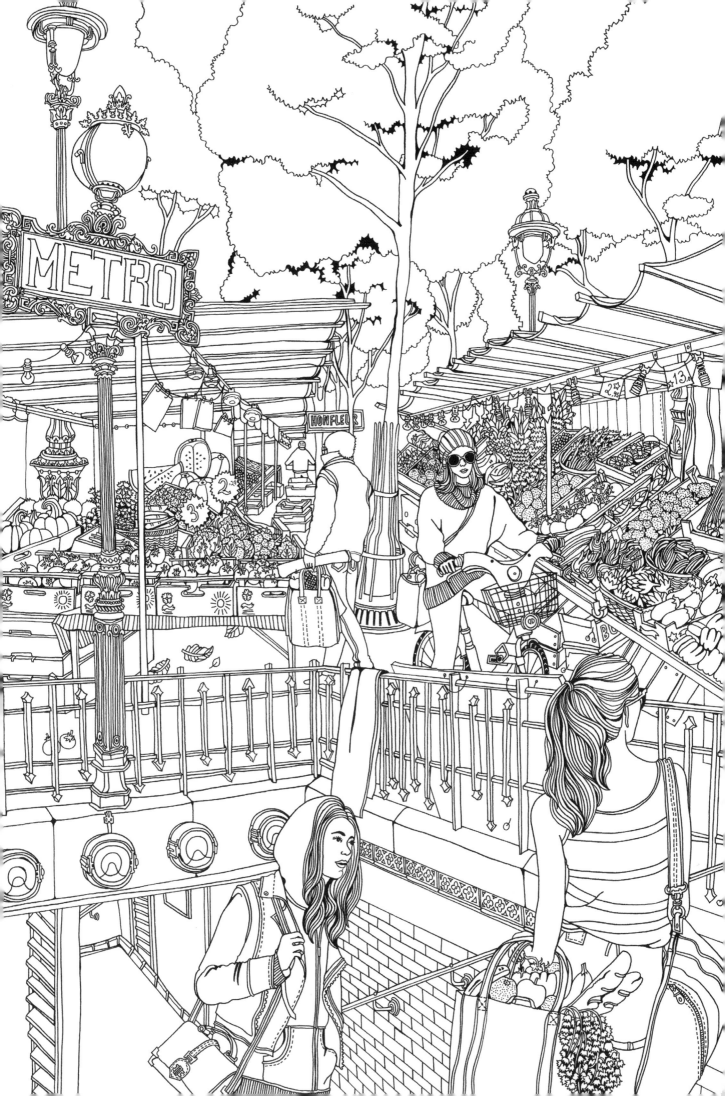

previous page

20.

Marché Monge

Vivid pyramids of oranges and onions, organic honey, trays of
crisp little macarons and éclairs, crackly ficelles, and thirty kinds
of cheese ... Marché Monge is held in the pretty Place Monge in
the 5th arrondissement, on Wednesdays, Fridays, and Sundays.
Despite plenty of visitors from outside the area, it remains small,
lively, and local: a true Parisian market in miniature.